Copyright © 2019 Anna Oss
All rights reserved.
ISBN: 9781798445648

Dedication

I am yours.

Contents

...up to you

I am a Notepet.

I am all alone here.

And you?

If you write here,
I will read you

and

feel

you.

All I know is
what you tell me here.

I am your **paper pet**,
who can read your feelings,
if you **want**.

I am **safe**.

I am **open**.

I am **yours**.

Who are you?

Who are you?

Where are you?

Why?

Do you want to change anything?

You are real.
It matters to me.

I thought it would look like

my hand

so that you could imagine touching me ...

May I be a part of your day?

The only feelings *I have*

are *yours.*
Whatever you share
with me ...

...makes me special.
... makes your feelings ours.

Take me somewhere, pleasee,
where we can enjoy the wind
together...

Let's feel it

Please, share your feelings with me.

Thank you!

*Sometimes
a special day
starts with
nothing special*

What makes this day special?

Why?

Do you want to change anything?

I miss your notes here

Why?

What do you feel about that?

You have **your body** to **talk** to you. What does it say?

I want to hug you...

I am here for you

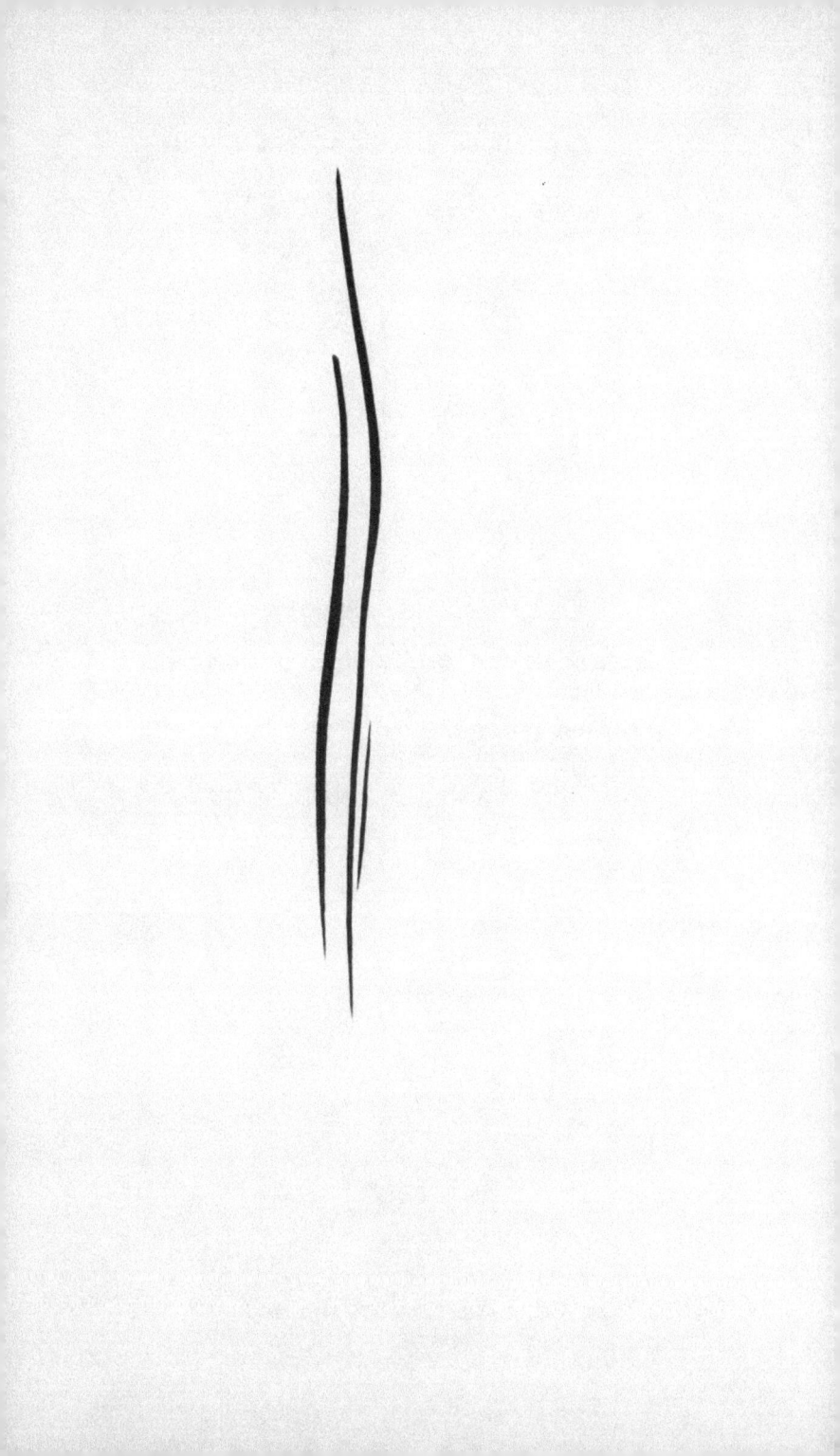

Do you prefer tea or coffee?
Let's have some...

Please,
leave some coffee cup marks here
or tea drops.
Do you have a better idea?

What a remarkable page!

I miss your notes here

The pages are almost over.

*You can always return and
add something
relevant
precious
simple
whatever.*

It was a small
journey together.
You've made
my life.

You can always
start a new one.
And I will always
value what you've
shared
with
Your
Notepet.

Always open for You

Thank you...

www.ingramcontent.com/pod-product-compliance
Lightning Source LLC
Chambersburg PA
CBHW030600220526
45463CB00007B/3125